Canon
PowerShot G11

Michael Guncheon

MAGIC LANTERN GUIDES®

Canon
PowerShot *G11*

Michael Guncheon

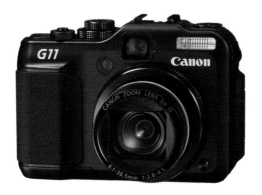

**LARK
PHOTOGRAPHY
BOOKS**

A Division of Sterling Publishing Co., Inc.
New York / London

Editor: Frank Gallaugher
Book Design and Layout: Michael Robertson
Cover Designer: Thom Gaines

Library of Congress Cataloging-in-Publication Data

Guncheon, Michael A., 1959-
 Canon PowerShot G11 / Michael A. Guncheon. -- 1st ed.
 p. cm. -- (Magic lantern guides)
 ISBN 978-1-60059-687-2
 1. Canon digital cameras--Handbooks, manuals, etc. 2. Photography--Handbooks, manuals,
etc. 3. Photography--Digital techniques--Handbooks, manuals, etc. I. Title.
 TR263.C3G98 2010
 771.3'3--dc22
 2009053710

10 9 8 7 6 5 4 3 2 1

First Edition

Published by Lark Books, A Division of
Sterling Publishing Co., Inc.
387 Park Avenue South, New York, N.Y. 10016

Distributed in Canada by Sterling Publishing,
c/o Canadian Manda Group, 165 Dufferin Street, Toronto, Ontario, Canada M6K 3H6

Distributed in the United Kingdom by GMC Distribution Services,
Castle Place, 166 High Street, Lewes, East Sussex, England BN7 1XU

Distributed in Australia by Capricorn Link (Australia) Pty Ltd.,
P.O. Box 704, Windsor, NSW 2756 Australia

If you have questions or comments about this book, please contact:
Lark Books, 67 Broadway, Asheville, NC 28801
(828) 253-0467
www.larkbooks.com/digital

Manufactured in Canada

ISBN 13: 978-1-60059-687-2

For information about custom editions, special sales, premium and corporate purchases, please
contact Sterling Special Sales Department at 800-805-5489 or specialsales@sterlingpub.com.

For information about desk and examination copies available to college and university professors,
requests must be submitted to academic@larkbooks.com. Our complete policy can be found at
www.larkbooks.com.

Contents

Basic Features and Controls 35

The FUNC. (Function) Menu 57

Shooting Mode Menus 73

Exposure 125

Flash and Accessories 143

Introducing the Canon PowerShot G11

TOP OF THE LINE IN FORM AND FUNCTION

The PowerShot line of Canon cameras has always stood for excellence in digital imaging. Since their humble beginning in 1996, these cameras have consistently stood on the forefront of new technology. Leading the charge have been the G-series cameras.

The G-series matches a desire by the photographer for outstanding camera operational control, with image quality like that found in a digital SLR, but in a smaller, compact package. The G11's body measures only 4.41 x 3.0 x 1.9 inches (112.1 x 76.2 x 48.3 mm) and weighs a lightweight 12.5 oz. (355 g). It is common to find a G-series camera tucked away in the camera bags of professional photographers around the world.

Building on the success of the G10, the G11 couples a newly designed 10-megapixel (MP) sensor with the Canon DIGIC 4 image processing engine, increasing low-noise performance by about two stops compared to the older G10. The camera also uses Canon's i-Contrast technology to help limit overexposed highlights in the image while still maintaining shadow detail.

Probably the most significant change between the G11 and the G10 is the new image sensor. Following recent trends, you would expect the pixel count to go up. Instead, it goes down from 14.7 MP on the G10 to 10 MP on the G11. I think the decrease to "only" 10 MP is an important indication of the end of "the megapixel wars." And I don't think that's a problem. First, just increasing the number of pixels doesn't necessarily result in an increase in image quality. The size of the sensor itself is a limiting factor. Sure, you can fit 5, 10, or 12 megapixels on a cell phone camera; but because its sensor is the size of a pencil eraser, the images it produces will never be on par with those from a PowerShot—even if the Powershot pixel count is less.

Second, most people do not take pictures that are going to end up as enlargements that require a huge pixel count. A good percentage of images end up as 4 x 6s or 8 x 10s, easily within the capability of images taken with PowerShot cameras. The G11, with its high-performance sensor, RAW recording capability, DIGIC 4 processor, and low noise performance, can produce high-quality prints that are 11 x 14 inches and larger.

A RETURN TO FLEXIBILITY—THE LCD SCREEN

One thing I really missed in the later model G-Series cameras was the articulating screen. I like shooting from different perspectives, particularly lower angles. The earlier G-Series models let me flip out the screen to compose a shot without lying in dirt, and they allowed me to get shots I would otherwise have had difficulty getting.

Fortunately, the articulating screen is back! The 2.8-inch (71.1 mm) LCD screen is comprised of 461,000 pixels and offers 100% view of the composed scene. The PureColor System LCD is designed to produce outstanding color and contrast even when viewing the image off-angle. The display swivels 170° horizontally and 280° vertically.

CLASSIC CONTROLS

While many digital cameras have gone the route of touch screens and joystick controls, the G11's control system is built on Canon's long experience of "what works." Instead of diving deep into cumbersome menus, or pressing and holding one button while rotating a dial, you can use the dedicated dials and buttons that are located right where

they are needed. Plus, there is a programmable "shortcut" button ⑤ that can be set for one of ten different functions. Using the G11 is an efficient and tactile experience. I can shoot for quite a while just by using the dedicated controls, rather than jumping into menus every couple of shots.

OPTICAL VIEWFINDER

The LCD is a very flexible option for composing your shot, but the G11 also offers something that fewer and fewer of today's compact cameras have: an optical viewfinder. An optical viewfinder solves two problems: blur caused by camera shake and visibility of the LCD.

First, blur. One of the most unstable ways to hold a camera is with your arms away from your body. This is the position you are typically forced into when you use the LCD. When you use the optical viewfinder, however, you bring your arms in close to your body and the camera can rest against your face. This makes for a more stable shooting platform and leads to sharper shots with less camera-induced motion blur.

Second, even though the G11's LCD is one of the brightest displays on the market, there are situations where the screen is obscured—typically in direct sunlight. The optical viewfinder lets you get around a difficult-to-see LCD. Keep in mind, however, that the viewfinder only shows you about 77% of the actual scene that will be captured. Check the edges of your frame when you review your images.

NOTE: The viewfinder has a diopter adjustment that may need to be adjusted, depending on your vision. The adjustment dial is immediately to the left of the viewfinder. While you look through the viewfinder, rotate the dial until the image looks sharp.

FILE FORMATS

The G11 can record images in two different file formats: JPEG and RAW. JPEG (Joint Photographic Experts Group) is a standard format for image compression, and the most common file created by digital cameras. It is popular because it reduces the size of the file, allowing more pictures to fit on a memory card, and is specifically optimized for photographic images. When the G11 records JPEG images, the DIGIC 4 image processor makes a number of adjustments and refinements so

the JPEG images look great right out of the camera, and can immediately be shared, printed, or uploaded to the Internet.

RAW files, on the other hand, contain almost all of the information detected by the sensor, with little to no processing applied by the camera. This allows you to do more of the processing later, in the computer, rather than having to "lock-in" processing in the field.

There has been a mistaken notion that JPEG is a file format for amateur photographers and RAW is a format for professionals. This is really not the case. Some pros use JPEG and some amateurs use RAW. There is no question that RAW offers distinct benefits for the photographer who needs them, including the ability to make greater changes to the image file before the image degrades from over-processing. The G11's RAW format (called CR2 and originally developed by Canon for the EOS-1D Mark II D-SLR) includes revised processing improvements, making it more flexible and versatile for photographers than previous versions. It can also handle more metadata and is able to store processing parameters for future use.

However, RAW is not for everyone. It requires more work and more time to process than other formats. For the photographer who likes to work quickly and wants to spend less time at the computer, JPEG offers clear advantages and, with the G11, may even give better results. This might sound radical considering what some "experts" say about RAW in relation to JPEG, but I suspect they have never shot an image with a G11 set for high-quality JPEGs. In any case, the G11 lets you shoot both RAW and JPEG simultaneously (RAW + ◢ L) to use the flexibility of RAW files to deal with tough exposure situations, and the convenience of JPEG files when you need fast and easy handling of images.

Which format will work best for you? Your own personal way of shooting and working should dictate that. If you deal with problem lighting and colors, for example, RAW gives you a lot of flexibility in controlling both. If you can carefully control your exposures and keep images consistent, JPEG is more efficient.

MANUAL OPERATIONS

Aside from image quality, one of the big reasons the G11 finds its way into the camera bags of professional photographers is its impressive set of manual controls. With one glance, a pro familiar with shooting a

^ The G11 offers enormous flexibility in setting up the camera to match various shooting situations.

digital SLR can pick up a G11 and immediately know how to set exposure modes, ISO speed, and exposure compensation.

The exposure modes **Tv** (Shutter priority) and **Av** (Aperture priority) are labeled and operate just like they do on an SLR. Once in **Tv**, it is easy to rotate the Control Dial ◎ to set the preferred shutter speed (from 15 seconds to 1/4000 second) as displayed at the bottom of the LCD. When **Av** is selected, ◎ is used to select aperture (from f/2.8 to f/8.0) using the aperture scale on the LCD. Full manual control **M** offers direct control of both shutter speed and aperture. When in **M** mode, ◎ initially controls shutter speed; press the Metering Mode button ⊡ to switch to the aperture scale, and use ◎ to adjust the aperture in 1/3-stop increments.

In fact, the G11 makes manual control even easier than most SLRs, via its dedicated ISO dial atop the camera. This intuitive interface makes adjusting the sensitivity of the camera much simpler than jumping into the menu system. The ISO range is from 80 – 3200 and also includes an auto mode that lets the G11 choose the ISO speed. There is also a dedicated exposure compensation dial on the upper left of the camera, making it easy to override the camera's metering system. A quick glance at the top of the camera tells you where exposure compensation is set. The exposure compensation range is +/- 2 stops in 1/3-stop increments.

While the G11 has a great autofocus system, it also allows manual focus. Press ▲ (labeled **MF**) on ◎ to bring up a focus scale on the right side of the LCD that shows the current focus distance. In addition, the center portion of the LCD is magnified to more easily evaluate focus.

ABOUT THIS BOOK

The goal of this guide is to help you understand how the camera operates so that you can choose the features and modes that work best for you and your style of photography. Canon created the multi-featured G11 so it would meet the requirements of photographers of all levels of experience.

Although this book thoroughly explores all of the G11's functions, you certainly don't need to know how to operate every one of them. You may decide that certain features are not necessary to master in order to achieve your desired photographic results. Learn the basic controls. Explore any additional features that work for you. Forget the rest. At some point in the future, you can always delve further into this book and work to develop your G11 techniques and skills. But just remember: The best time to learn about a feature is before you need to use it.

⌃ This guide is small enough to easily fit into most any camera bag, for quick, in-the-field explanations of the G11's many features.

CONVENTIONS USED IN THIS BOOK

When the terms "right" and "left" are used to denote placement of buttons and features, or to describe camera techniques, it is assumed that the camera is being held in the shooting position, unless otherwise specified. Pixel counts on image sensors are always approximate. The G11 has approximately 10.4 million pixels, but is considered a 10-megapixel camera. When describing the functionality of the G11, it is assumed that the camera is being used with genuine Canon accessories, such as Speedlites, converters, and batteries.

ACKNOWLEDGEMENTS

This book would be impossible to write without the help of many people. Thank you to Rudy Winston, Len Musmeci, and Chuck Westfall at Canon. I would also like to thank the gang at Lark Photography Books for all of their support, especially Haley Pritchard, Kevin Kopp, Kara Arndt, Frank Gallaugher, and Marti Saltzman. Lastly, I couldn't do any project like this without the help of my wife, Carol.

Getting Started

Although you may want to pick up your new camera and just start shooting, here are a few initial steps to take with the G11 to ensure success.

THE BATTERY AND MEMORY CARD

The battery and the memory card are accessed through a shared door on the bottom of the camera. Place your finger or thumb on the door and slide it towards the edge of the camera. A spring built into the door will pop it open.

‹ The G11 can use the SDHC version of SD memory cards. SDHC offers large capacities like 4GB, 8GB, and more. Opt for several medium-size cards rather than one large card.

BATTERY

The G11 is powered by a Lithium Ion battery—the NB-7L. With a capacity of 1050mAh, the NB-7L battery packs a lot into a small package. Milliamp hours (mAh) indicate a battery's capacity to hold a charge. Higher mAh numbers mean longer-lasting batteries.

The NB-7L is rated at 7.4 volts and takes about two hours and twenty minutes to fully charge on the CB-2LZ charger included with the camera. Out of the box, the NB-7L may have some charge, but resist the temptation to grab the camera and go. The battery will give you better performance if you start it out on the right foot by fully charging it before you first use the camera.

> The G11 comes with a high-performance battery and charger combination. For best results, use batteries that are made by Canon.

To charge the battery, place it in the CB-2LZ charger and plug the charger into an outlet. The charger can operate on both North American and overseas voltages. An LED indicates that the battery is charging and a second LED lights when the charge is complete. Rechargeable batteries lose a bit of charge every day, but this doesn't mean you should leave the battery on the charger all the time. As few as 24 consecutive hours on the charger may damage the battery, so get in the habit of charging your battery only the day you need it, or possibly the day before.

To insert the battery in the camera, make sure the Canon logo on the battery is facing toward the back of the camera, and the arrow is facing toward the battery compartment. Gently push the battery into the compartment until the orange battery lock secures the battery in place. To remove the battery, push the battery lock away from the battery and it will pop up. I recommend that you buy an additional battery so that you always have a spare.

MEMORY CARD

The digital film in the G11 is the memory card. The camera supports a variety of memory card formats: SD, SDHC, MMC, MMCplus, and MMCplus HC. The most common cards you are likely to see are SD and SDHC. SDHC is a high-capacity version of SD, allowing storage greater than 4GB.

Although SD and SDHC look identical (only their logos are different), it's important to know which type you are using. SDHC-capable slots, including the one in the PowerShot G11, have no problem using regular SD cards, but the reverse is not true. This simple rule applies: SDHC-capable devices (cameras, card readers, and printers) can use either SD or SDHC cards, but SD devices can only use SD cards. Remember to look for the SDHC label on all your devices if you plan to use SDHC. If this is your first camera and card reader (see page 31), I recommend you stick to SDHC cards.

To insert the card, orient the contacts towards the card slot, facing the back of the camera. Gently push the card into the camera. You'll hear a soft click and the card will be locked in place. To remove the card, press gently on the edge of the card and it will gently pop up.

Formatting the Memory Card: Always format a new memory card in the camera. To format, press MENU and then use ◄► (labeled ♨ and ⚡) on the Control Dial ◎ to select ⚙. Then use ▲▼ (labeled MF and ↻) to select [Format...] and press ⊛. You have the option of selecting a low level format. Although it takes a little more time and power, I recommend it for trouble-free operation.

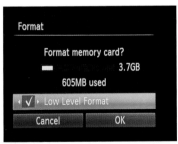

‹ Format memory cards only in the G11. Make sure you test out new memory cards by formatting, taking pictures, and then downloading images several times.

WARNING: Formatting erases all data on the card. There is no undo.

CAMERA DATE AND TIME

When you first get your G11, it won't know what time or day it is, and its default language will be English. So on initial power up it will ask you to set the date and time. If you don't set the date and time at first, then you can always access that setting from the 🍴 menu.

> Don't skip this important step! It will will help you when you are searching through your images if the date and time of the image files are correct.

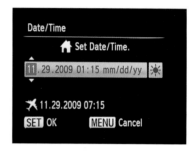

Use ◄► to select the portion of the date and time you want to set and then use ▲▼ or rotate ◎ to adjust the value. The G11 supports Daylight Saving Time, but you need to set it manually. Be sure to set the time zone also. The G11 can store a home time zone 🏠 and a travel time zone ✈. If you switch to ✈ when you travel, after you return, it will be easier to keep track of when you take your pictures.

> If you don't pay attention to switching the time and date when traveling, then you could end up with images that appear to have been taken a day before or after they really were taken.

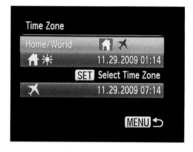

NOTE: Built into the G11 is a small date/time battery that maintains the date, time, and many other camera settings when you replace the NB-7L battery. This internal battery gets its charge from the NB-7L. If you should leave the NB-7L battery out of the G11 for an extended period of time, the internal battery may become completely discharged and the date and time will be lost. Inserting a charged NB-7L will quickly recharge the time/date battery.

SET THE LANGUAGE

Although you can access the language-setting screen via ⚙, there is a quicker way. It is especially useful if you find the camera set for a language that may prevent you from finding your way back to the language-setting menu. Press ▶, then, while holding down ⊕, press MENU. A list of languages will be displayed on the LCD. Turn ◎, or use ◀▶ and ▲▼ to select the language, then press ⊕.

ATTACH THE NECK STRAP

The G11 is an advanced piece of optics and electronics, so it works best when you don't drop it. That seems like an obvious statement, but too often people forget to attach the neck strap to their camera and then suffer the results.

To attach the neck strap, lay it out on a surface so that when you attach it to the G11 there isn't a twist. When attached, the side of the strap with the Canon logo should be opposite the side that lies on the back of your neck. I recommend that you follow the instructions below, attaching one side at a time so that you can refer to how the strap is threaded into the locking buckle.

First, note the fold at the end of the strap. This is where the camera's strap mount should rest when the strap is attached. Next, push the strap end back through the locking buckle so that you can release the free end of the strap. Pull it back through the locking buckle so that the free end is released. Remove the free end from the plastic retainer.

Paying attention to the orientation of the strap, thread the end through the strap mount on the G11. Make sure that the fold in the strap is nestled into the strap mount. Thread the strap end back through the retainer, then thread it back through the locking buckle and take up the slack. Repeat the process on the other end.

^ When you first start using your G11, AUTO mode will give you good exposure results in many situations.

YOUR FIRST PICTURES

Now that you have charged the battery and have inserted and formatted a memory card, it is time for some photography. Press the ON/OFF button on the top of the camera. The startup sound is heard, the lens extends, and the LCD turns on.

NOTE: You can turn the camera on and mute the normal startup sounds and other camera beeps (except warnings). Press and hold the MENU button while turning on the camera. This mutes all sounds except warnings. It achieves the same result as going into ⁋⁋ and setting the **[Mute]** option to **[On]**.

For your first pictures, set the G11 to **AUTO** using the Mode Dial on the top of the camera. This fully automatic mode will take care of exposure and focus. You need only to frame up the shot and press the shutter release button. You can compose using either the LCD or the optical viewfinder.

To take a picture, gently press the shutter release button. When you press halfway the G11 evaluates the scene and sets the camera's

exposure. It also attempts to set focus. If the camera succeeds, it will beep and you can press the shutter release all the way down to take the picture.

You can use the small indicators to the right of the optical viewfinder to see if the camera is ready to take a picture. If the top indicator is orange and blinking, it means that the camera is using a long shutter speed and handholding the camera may cause image blur. If it is orange and solidly lit, it means the flash is ready. If it is green and solidly lit, the camera is ready to take the shot. If the lower indicator (yellow) blinks, the camera is having difficulty focusing.

When you take the picture, the LCD will momentarily black out, you'll hear a shutter sound, the green indicator by the viewfinder will blink to let you know that the image is being written to the memory card, and the image will also be displayed on the LCD. After two seconds, the captured image will disappear from the LCD and be replaced by the live image. You can take another picture without waiting for the live image to reappear on the LCD by pressing the shutter release button again.

IMAGE PLAYBACK

You can display images recorded on the memory card by pressing the Playback ▶ button. The last image that was shot will be displayed. If the G11 is powered down, you can simply press ▶ to turn on the camera and display the last image captured. You can advance through your images using ◎. This will cause each image to slide across the LCD. A quicker method is to use ◀▶ (labeled ♣ and ⚡). If you press and hold ◀ or ▶ the images will cycle through much more quickly.

DELETING IMAGES

Images can be deleted from the memory card while the camera is in playback mode. Press ▶, use ◎ or ◀▶ to display the image you want to delete, and then press ⌫. An erase dialog will be displayed. Use ◀▶ to highlight [Erase] and press ⊛. Note that the image is permanently deleted. There is no undo!

PRINTING IMAGES

The G11 supports direct connection to printers. With the printer and the camera powered off, connect the G11's A/V OUT digital terminal on the right side of the camera to the printer's PictBridge port using the USB cable that comes with the camera. Turn on the printer, and then press ▶ to turn on the camera. If the connection to the printer is successful, ⫯ will be displayed in the upper left-hand corner of the LCD. Use ◎ or ◀▶ to select the image you want to print. Press ⎙ to print the image. When you are finished printing, power down the camera and the printer, and disconnect the cable.

DPOF: The G11 supports the Digital Print Order Format standard, which allows you to embed printing instructions in a batch of image files. This way you can use your camera to select the images you want to print, and then take your memory card to a photo lab to have the selected images printed. Or, when you connect the G11 directly to a printer, you can automatically print out the previously selected images.

If you want to mark an image for printing immediately after you take the picture, press ⎙ while the image is still displayed on the LCD. An "Add to Print List?" dialog will pop up. Use ◎ or ◀▶ to select [Add]. Use ▲▼ to select how many prints you want, and then press ⓜ. A DPOF print order icon ⎙ will display on the image, together with a numeral indicating the number of copies to be printed.

To select images during playback, rather than immediately after shooting the picture, press ▶ to enter playback mode. Use ◎ or ◀▶ to select an image to add to the print list and press ⎙. As before, use ◎ or ◀▶ to select [Add]. Use ▲▼ to indicate how many prints and press ⓜ. To remove images from the Print List, press ⎙ and use ◎ or ◀▶ to select [Remove], then press ⓜ. This is also how you can change the quantity.

Using the Print List: When you connect the G11 directly to a PictBridge-compatible printer as described above, the print list screen will display on the LCD. The images that have been added to the print list will be displayed, along with the quantity of prints "ordered." The display will also indicate how many sheets of paper are required to print the whole order. Use ◎ or ◀▶ to scroll through the print list. Use ▲▼ to highlight [Print] and press ⓜ to start the printing process. Highlight [Print Later] to skip the print list and return to manual selection of images for printing.

RECORDING MOVIES

Use a memory card with plenty of empty space when you shoot movies, as movie files can take up much more room than image files. Turn the camera on and set the Mode Dial to ',凘. Set your zoom using the zoom lever. Press the shutter release button half way to set exposure and focus. The camera will beep and the upper indicator on the viewfinder will light a steady green, indicating that the camera is ready to start recording. Press the shutter release all the way to begin recording. Press it a second time to stop recording.

During recording, the LCD will display ● Rec to indicate the camera is recording. At the top of the LCD, numbers will show the current length of the recording in minutes and seconds. The maximum length of recording is 1 hour, even if your memory card supports more. A 2GB card will be able to record nearly 23 minutes.

> **NOTE:** Audio from the built-in microphone is recorded along with the video. The microphone is located atop the camera near the ISO Speed dial. This microphone will pick up the sound of any adjustments you make to camera settings.

MOVIE PLAYBACK

To view your movies, press ▶ to enter playback mode. Use ◎ or ◀▶ to select the movie you want to view. You can tell the difference between a still image and a movie on the LCD by the 凘 icon in the upper right corner that is displayed on movie files. Press ◉ to bring up the movie controller. By default, the play button is highlighted. Press ◉ to start playback. Use ▲▼ to adjust playback volume.

To delete a movie, press ▶, use ◎ or ◀▶ to display the movie you want to delete, and press 🗑. An erase dialog will be displayed. Use ◀▶ to highlight **[Erase]** and press ◉. Keep in mind that the movie is permanently erased.

^ While the LCD on the back of the G11 displays a great image, the best place to look at your images is on a computer screen. It is there that you can critically evaluate and adjust your picture.

TRANSFERRING IMAGES TO A COMPUTER

The G11 comes with software that facilitates the transfer of images from your camera to the computer. The software is contained on the Digital Camera Solution CD-ROM that comes with the camera. The disc contains software for both Mac OS X and Windows.

MACINTOSH INSTALLATION

Once the disc is inserted into the drive it should appear as an icon on your desktop. Double click the icon to open a window showing the contents of the disc. Double click the Canon Digital Camera Installer application. Select the area in which you live, select the country, and click Next >. Click on the Digital Camera Software Install button and choose Easy Installation, then click Next >. Read and accept the software end-user license agreement and click Next >. Software installation will begin. After installation, eject the software disc.

WINDOWS INSTALLATION

Insert the disc into the drive and wait for the sound of drive activity to stop. A Digital Camera Solution Disk button will appear on your Task Bar. If the first screen in the installation process doesn't appear as well, click the Task Bar button to display it.

Select the area in which you live, then the country, then click Next. Select your language. Click Easy Installation in the next screen. Close any other applications that are running, then acknowledge the note to close other applications (click OK). In the following screen, click Install. Read and accept the software end-user license agreement by clicking Yes. Software installation begins immediately. You may also be prompted to install Microsoft's .NET Framework and/or to read and accept its end-user licensing agreement (click Yes). Wait while the .NET Framework components are configured (it may take several minutes).

Once the software installation is complete, leave the CD in the drive and click Next. You're almost through! You can either register the software now or select "No, I will register later," and click Next. (If you register later, you'll need the CD and must enter your regional area and language again.) Click Restart to restart your computer, and remove the CD from the drive.

CAMERA-TO-COMPUTER CONNECTION

The connection to the computer is via the USB cable that comes with the G11; this is the same cable you use to connect to a printer. With the camera turned off, connect one end of the cable to the USB port on your computer and the other end to the A/V OUT Digital terminal on the right side of the G11.

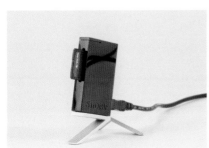

‹ An alternative transfer method is to get a dedicated card reader like this, which is powered by the computer itself and thus avoids the risk of mid-transfer power failure.

DOWNLOAD IMAGES

With the camera connected to the computer, press ▶ to turn the camera on and enter playback mode. On a Macintosh, the Canon Utilities Camera Window application should appear. On a Windows computer, a Canon PowerShot G11 window will open, in which you should select [Canon Camera Window] and click OK.

Choose [Import Images from Camera] from the list of options. You can then choose from three further options:

O Import Untransferred Images: If you have previously transferred images to your computer, then you can use this option to transfer only the new images.

O Select Images to Import: This option will bring up a window showing thumbnails of all the images on the camera. Shift+Click or Command+Click (Mac), or Shift+Click or Ctrl+Click (Windows), to choose the images you want to import, and then click Import.

O Import All Images: Use this if you want to transfer all the images and movies to your computer.

By default, files are transferred to the Pictures folder of the current user. They are placed in subfolders based on the date the images and movies were created.

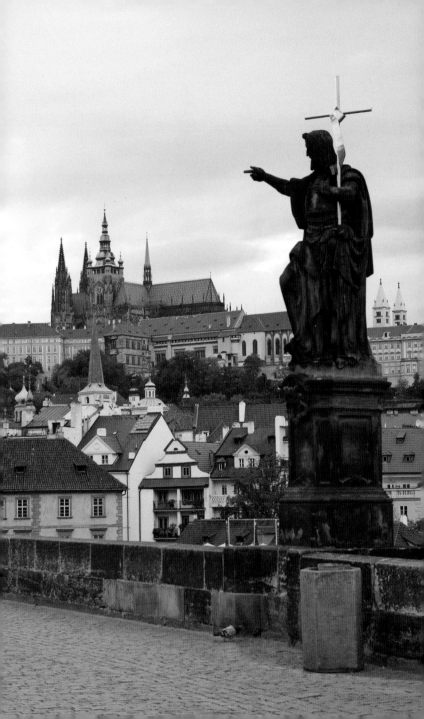

Flash and Accessories

Although the G11 gives great results in low-light situations, there will always be a time when you'll need to supplement the lighting with flash. This can be done with the built-in flash or an external flash.

BUILT-IN FLASH

The built-in flash on the G11 has a range of 1.6 – 23 feet (50 cm – 7.0 m) when the lens is at full wide angle and 1.6 – 13 feet (50 cm – 4.0 m) when at full telephoto.

BUILT-IN FLASH MODES

To access the different flash modes, press ⚡. The available modes differ according to the shooting mode. Flash is not available when the G11 is in movie mode.

⚡ᴬ Auto: This lets the G11 control when the flash will fire. If, after metering the scene, there is not adequate exposure, the camera will set the flash to fire, and adjust the duration of the flash to achieve a properly exposed shot. This mode is available in P, AUTO, ☀, ≡☐, 🐟, 🎇, 🎿, 🏂, 🎐, ✂, 💣, Aᴬ, and As.

 If the flash fires in 🏔, 🄰, 🌄, or 🖼 modes, then the flash will operate as if ⚡ᵢ has been selected (see below).

⚡ On: In this mode the flash will always fire, regardless of the exposure, and therefore this is a good option to use when photographing people in bright sunlight. The flash acts as a fill flash to reduce or "fill in" harsh shadows. This mode is available in **M**, **Av**, **Tv**, **P**, 🎥, 🐟, 🏃, 🏖, 🌊, 🎆, 🍴, ✂, 🍽, 🅰, 🅸, and 🖥.

If the flash fires in 🏔, 🎐, 🌅, and 🌃 modes, then the flash will operate as if ⚡ has been selected (see below).

NOTE: When you use **C1** and **C2**, the flash modes and the built-in flash settings menu depend on the settings you've saved.

⚡ Slow Synchro: Normally, flash freezes the action. With Slow Synchro, a slow shutter speed is used with flash. The slow shutter speed allows ambient background light to set the scene while the flash lights the main subject. Because it is a slow shutter speed, a tripod or steady hand is required. This mode is only available in **Av**, **P**, 🎥, and 🖥.

🚫 Off: This mode prevents the flash from firing and is useful in museums or at any time when using flash is not appropriate. The flash can be turned off in all modes.

BUILT-IN FLASH SETTINGS MENU

If the built-in flash is engaged you can make further adjustments via the Built-In Flash Settings menu. You can access it in the following ways: (1) When the flash mode screen is displayed, press MENU; (2) Select **[Flash Control...]** in the 📷 menu and press ⑭; (3) Press and hold ⚡ for two seconds. Once the menu is displayed, you have the following options:

> The Flash menu allows you to set a separate flash exposure compensation so that the flash doesn't overwhelm the scene.

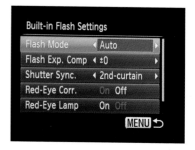

FLASH MODE

When set to [Auto], the camera controls the power of the flash, but you can override it to some degree with Flash Exposure Compensation. This mode is not available in M, ✎, or ▦ shooting modes. Select [Manual] for complete control of the flash output. Manual flash mode is available only in M, Av, and Tv shooting modes.

FLASH EXP. COMP

Although the G11 does a good job of balancing exposure with flash, use this control to "dial down" the amount of flash used in the scene. This control is often the difference between an obvious flash shot (the deer-in-headlights look) and a well-balanced, natural-looking shot. If you shoot with flash, make sure you know this control. You can add or remove up to two stops of flash illumination in one-third step increments. This is available only in Av, Tv, P, and ▰ shooting modes.

FLASH OUTPUT

This option is available only in M, Av, and Tv shooting modes. Unlike flash exposure compensation, flash output is consistent no matter what the camera meter measures. You can set the output to [Minimum], [Medium], or [Maximum].

SHUTTER SYNC.

The G11 is equipped with an electromagnetically timed shutter that travels across the sensor in order to expose it for a specific amount of time (the shutter speed). The shutter works via two "curtains." At the start of the exposure, the first curtain opens; at the end of the exposure, the second curtain closes. With longer shutter speeds, you can "sync" the flash to either the first or second curtain, allowing the sensor to receive both the light from the flash and the more distant ambient light from the longer shutter speed.

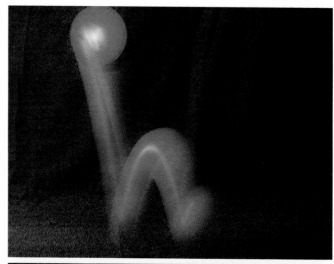

^ These images were captured using the same motion of the ball being dropped.
The top image used the default first-curtain shutter, and the ball appears to be
bouncing up and out of the scene. The bottom image used second-curtain sync, and
portrays the correct direction of the ball's motion.

Imagine a baseball pitcher throwing a ball at a night baseball game.
If you take a flash picture, the sequence is: first curtain opens, flash fires,
shutter remains open for the rest of the exposure, second curtain closes.
While the shutter remains open, the image sensor still gathers ambient

light in the scene. When you look at the picture of the pitcher when [1st-curtain] is selected, you'll see that it looks like the pitcher is pulling the ball back towards himself. This is because the flash fires at the beginning of the exposure, freezing the action of his arm. Then the pitcher's arm travels forward, lit by ambient light. So the final image has a blurry trail preceding the moving arm. This is the opposite of what we are used to seeing—motion expressed as trails following a moving object.

If [2nd-curtain] is selected, the flash fires just before the second curtain closes, so the motion trails lead up to a frozen subject, and the image looks more normal. This is only necessary for slow shutter speeds when there is ambient light.

RED-EYE CORR.

Because the built-in flash is very near to the axis of the lens, light from the flash can easily reflect off the back of people's eyeballs, creating the red-eye effect. Red-eye correction is one method of dealing with this problem. When this function is set to [On], if the G11 sees that you are using flash and notices red-eye in the image, it will use the DIGIC 4 processor to fix the red-eye before it saves the image to the memory card. Be aware there is a chance that the camera will see red-eye where there isn't any. If you are concerned, use the red-eye correction feature in the playback menu. Red-Eye Correction is available in all shooting modes except ✤, ▨, ⒜A, ⒜S, and ⬚.

NOTE: If the camera is set to record RAW files, then red-eye correction will not be available.

RED-EYE LAMP

Another alternative to fixing the image through red-eye correction is to reduce the opening of people's irises to limit the amount of light that reflects back to the camera. When this feature is set to [On], the G11 uses a powerful white LED on the front of the camera to cause people's irises to close. It is only fired when the flash is used. Set this to [Off] if you are trying to be discreet, as the LED light can be quite distracting. Red-Eye Lamp is available in all shooting modes except ✤ and ▨.

^ Don't be afraid to use flash outdoors to fill in harsh shadows.

SAFETY FE

There are times when the flash illumination is too great for the scene. This can happen during close-up photography. When this function is set to [On], the G11 adjusts shutter speed or aperture to prevent overexposure. In most scene modes, safety FE is on automatically; it is not available in **M**, ⚒, and ▓ shooting mode.

FE LOCK

There are times when you may want to lock in exposure with a different image composition than the final picture. Use FE lock to lock in the flash exposure. With the flash set to fire, press ✳. A low-power flash will fire, the camera meter will evaluate the scene, and the camera will lock in the exposure and flash output level (✳ will be displayed on the LCD) until you fully depress the shutter release to take the photograph. FE lock is not functional when the flash mode is set for manual.

The G11 has a hot shoe that allows for the use of external flash units. Using an external flash opens up opportunities for better flash photography:

Bounce Flash: Many external flashes have an articulated head that allows you to point the light up or to the side to reflect the light off ceilings and walls. This creates a larger light source, resulting in softer, more natural-looking light.

Extended Range: The built-in flash on the G11 has a maximum range of between 13 and 23 feet (4 – 7 m) depending on whether the lens is set for wide angle or telephoto. With an externally mounted flash, that distance can jump dramatically.

Off-Camera Flash: One of the biggest reasons people don't use flash is the deer-in-headlights look of the photos. By using a Speedlite on the camera, you have creative options for positioning the flash. Off-camera flash use can create more natural shadows and allow you to feather the light so that your subject isn't overexposed.

For best results, use the EX series of Canon Speedlites. When a Speedlite is attached and turned on, a red ⚡ will be displayed near the upper-right corner of the LCD to indicate an external flash is enabled. If the G11 is in an autoexposure mode and the flash mode is set to [Auto], the G11 will control the flash exposure.

Just as you can make adjustments to the built-in flash, you can adjust the external flash settings. To display the External Flash Settings menu, attach an external flash unit, then press and hold ⚡ for two seconds; or press MENU and in the ◻ menu select **[Flash Control...]**, then press ⓦ. The External Flash Settings menu is similar to the one used for the built-in flash, but with some differences.

FLASH MODE

Keep in mind that there are flash mode settings on the Speedlite that will affect the flash mode setting in the G11. Fortunately, the camera and the Speedlite communicate with each other. If you set the flash mode on the camera, then it will be changed on the Speedlite; and if you set the mode on the Speedlite it will be changed in the camera. If you are using a Speedlite that is set for Multi Strobe, you will not have access to the Flash Control menu.

O **[Auto]**: The light output of the Speedlite is controlled by the camera.

O **[Manual]:** Use this option for complete control of the flash output.

FLASH EXP. COMP

This adjustment is similar to the one for the built-in flash. Because of the increased power level of the external Speedlites, however, the flash exposure compensation range expands to +/- 3 stops.

FLASH OUTPUT

You can adjust external flash output with far more precision. When you use a **580EX** or 580EX II Speedlite, the output ranges from 1/128 to full power in one-third-stop increments. With other supported Speedlites the range is 1/64 to full power. If you use an older Speedlite, the flash output will always be full power.

SHUTTER SYNC.

As mentioned previously, the shutter on the G11 is comprised of two curtains. When you use faster shutter speeds, the second curtain starts to close before the first curtain has finished opening and the whole image

∧ Hi-speed sync is the only way to use fill flash on a bright, sunny day. Fortunately, the native sync speed of the built-in flash is already quite fast at 1/2000 second. © Matt Paden

sensor is never exposed to the scene at the same time. At speeds above 1/250 of a second—called the flash sync speed—the shutter curtains form a moving slit that partially exposes the image sensor. This means that a single burst of the flash will not completely illuminate the scene. Certain Speedlites offer a high-speed sync option that uses several lower power bursts as the shutter curtains travel across the sensor.

When you mount a 580EX II or 430EX II flash unit, you will either be able to select [Hi-speed] from the External Flash Settings menu or you will have to engage the feature on the flash unit itself. If you don't have a Speedlite with a high-speed sync option, the maximum shutter speed will be 1/250. The sync speed of the built-in flash is 1/2000.

NOTE: [2nd-curtain] is unavailable when the 580EX II is in wireless mode.

SLOW SYNCHRO

When using an external Speedlite, the Slow Synchro mode is not set using the normal G11 flash mode. Instead it shows up in the flash menu. In P, Av, and ⚞ you have the choice of [On] or [Off]. With Tv and M slow synchro is always set to [On].

WIRELESS FUNC.

The Canon Speedlite system includes wireless technology that allows Speedlites to control each other wirelessly. When a 580EX II is mounted on the G11, the **[Wireless Func.]** option appears, allowing you to set the Speedlite's wireless feature to **[On]**. The wireless settings can be further adjusted on the back of the flash. Shutter Sync will be **[1st-curtain]** and 2nd-curtain sync will not be available.

CLEAR FLASH SETTINGS ...

Select this option to return to the default external flash settings. This does not clear any custom functions that may be set in the Speedlite.

FLASH EXPOSURE LOCK

When shooting with an external flash, flash exposure lock (FEL) works the same as with the built-in flash (see page 137).

POWERSHOT FLASH

If you don't need the power and flexibility of a Canon Speedlite but want to extend the range of the built-in flash, try the Canon High-Power Flash HF-DC1, designed for use with most PowerShot cameras. It works in concert with the built-in flash.

The flash comes with a small flash bracket that attaches to the underside of the G11. It can also be set up away from the camera. There is no connection wire between the flash and the camera. The HF-DC1 is triggered by the light coming from the built-in flash.

ACCESSORIES

The PowerShot G11 has a variety of accessories to make your camera even more versatile and convenient.

FLASH ACCESSORIES

To get the Speedlite off the camera you'll need a flash cord. The Off Camera Shoe Cord OC-E3 allows you to have full communications between the G11 and the Speedlite even when you move the flash off the camera.

Since the hot shoe is located on the top of the G11, when you shoot with the camera in a vertical position, shadows caused by the flash will appear to the left or right of your subjects, rather than below them. For vertical shooting, use the optional SB-E2 Speedlite Bracket, together with the OC-E3 Off Camera Shoe Cord.

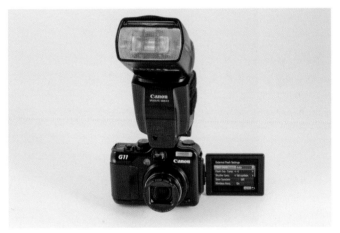

^ The Canon 580EX II Speedlite offers a lot of power and can be controlled via the G11 external flash settings menu.

You can fire many Canon Speedlites wirelessly using the ST-E2 Speedlite Transmitter. This small hot shoe-mounted device doesn't help illuminate the scene; instead, it controls remote Speedlites like the 580EX II and the 430EX II.

Canon offers two macro Speedlites, the Macro Twin Lite MT-24EX and the Macro Ring Lite MR-14EX. These are useful for close-up illumination and offer full autoexposure control like any Speedlite. In order to use these Speedlites, you'll also need to use the Conversion Lens Adapter LA-DC58K, the Off Camera Shoe Cord OC-E3, and the Bracket BKT-DC1.

> The TC-DC58D Tele-converter lets you zoom in close enough to isolate details and find creative abstractions.

TC-DC58D TELE-CONVERTER

Although the G11 doesn't have an interchangeable lens, you can add a lens converter to increase the telephoto range of the built-in zoom lens. The TC-DC58D Tele-converter lens increases the zoom range about 1.4 times. In order to use the TC-DC58D you'll also need the LA-DC58K Conversion Lens Adapter. To attach the tele-converter:

1. Press and hold the ring release button on the front of the camera.
2. Gently rotate the front lens ring counterclockwise and lift the ring off.

3. Line up the conversion lens adapter mark ● with the ● mark on the front of the camera.

4. Press MENU. From the 📷 menu, select **[Converter]**, and press ▶ to select **[TC-DC58D]**.

When using the tele-converter be aware of the following:

○ The tele-converter is really designed for the telephoto section of the G11's zoom lens range. If you try to use the wide-angle part of the zoom range, the corners of the image will be cut off.

○ The length of the tele-converter will block some of the light coming from the built-in flash. The lower right-hand corners of your image will be darker.

○ The tele-converter will block part of the view of the optical viewfinder. Use the LCD for shooting when you use the tele-converter.

○ You cannot use the tele-converter when you shoot in 📷 mode.

○ Make sure you turn the **[Converter]** option in 📷 to **[Off]** when you are not using a tele-converter.

○ When you use 📷 for panorama shooting, shots taken with the tele-converter cannot be stitched automatically using the included software.

RS60-E3 REMOTE SWITCH

If you want to use slow shutter speeds to capture fluid waterfalls or fireworks displays, a remote switch is a great tool to have. The RS60-E3 remote switch allows you to have remote control of the shutter button.

WP-DC34 WATERPROOF CASE

You can use this case when you shoot in severe elements like river rafting or snow skiing, but this case really shines for underwater use. Rated for a maximum depth of 130 feet (40 m), the case gives you control of most of the buttons, knobs, and switches on the camera.

ACK-DC50 AC ADAPTER KIT

If you need to shoot with the G11 for long periods of time, an AC adapter kit is invaluable. The adapter works by replacing the battery with a special battery-shaped case that connects to an AC-to-DC converter.

Index